Christopher W.

GUSTAV KLIMT

Prestel

Munich · Berlin · London · New York

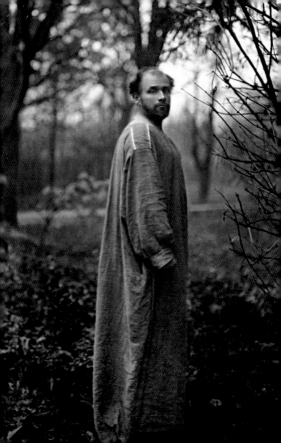

Portraits and Landscapes

"Scandalous, obscene and pornographic" was
how one contemporary critic described the work
of the celebrated painter of women Gustav Klimt
(1862–1918). Although his depictions of the
femme fatale and his sexually explicit drawings
have secured Klimt a place in the history of erotic
art, the most famous works by this Austrian
artist are his portraits and the sensual paintings
of his 'golden period'.

While portraiture remained both an important
source of income and a dominant theme through-
out his career, in the last two decades of his life
Klimt spent the summer months painting land-
scapes of exceptional intensity and beauty. These
evocative depictions show the artist from a differ-
ent perspective, capturing the atmosphere and
light of the mountainous landscape and the
colours and charm of farmhouse gardens and

orchards. Although generally not so well known, Klimt's landscape paintings are considered by many experts to be his most exquisite works.

Portraits and landscapes: two very different genres. However, a close look at Klimt's work reveals that there are surprising similarities in the composition of these paintings and in his use of colour (e.g. pages 20/29).

Seemingly contradictory elements can be found more easily in contemporary reports on the artist's personality and lifestyle. While one of Klimt's sisters maintained that her brother spent most evenings at home with their mother and two other sisters with whom he lived all his life, different sources tell of the artist's love of Viennese bars where he would play bowls and share a drink with friends. His unkempt appearance and rather brusque manner concealed an agile mind and his burly physique certainly did not hint at his sensitive nature. He had a passion for literary classics, yearned for peace and quiet, loved flowers and chose his studios according to the

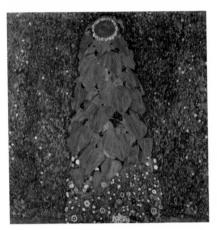

The Sunflower, 1907. A similar composition and use of colour can be found in several portraits.

size of their gardens. Although reserved and taciturn by nature, the home-loving bachelor is nonetheless attributed with numerous affairs and reputedly fathered fourteen children.

Klimt's artistic career started with decorative works for public buildings, including frescoes for

the new Burg Theatre in Vienna. This led to a commission from Vienna University and Klimt embarked on three huge canvases representing the faculties of Philosophy, Medicine and Jurisprudence. Work on this commission stretched over a ten-year period, during which he was increasingly exposed to the different influences of European avant-garde painting – not least of all as a result of the famous Vienna Secession.

As one of a radical group of Viennese artists, Klimt himself played a pivotal role in the formation of the Secession and became its first president in 1897. When *Philosophy*, the first of the University paintings, was exhibited in early 1900, a storm of protest was unleashed, only to be surpassed one year later by the response to *Medicine*. As a result, Klimt turned away from state patronage and devoted himself instead to his fresco, the *Beethoven Frieze* (see fold-out), painted for the 14th Secession exhibition in 1902. The stylised, symbolic language of the late 1890s culminated in this monumental work – an

interpretation of Beethoven's *Ninth Symphony*, depicting the struggle for happiness and the conquest over the 'hostile powers' of disease, insanity and death (see pp. 39/40). Klimt experimented with mixed media adding both silver and gold paint, as well as working with pieces of coloured glass and mother-of-pearl. The final section focuses on a theme that is repeated in Klimt's most famous work of all, *The Kiss* (see p. 22), and emerges again in the *Stoclet Frieze*.

This freeze for the dining room in the Palais Stoclet in Brussels formed part of a 'complete work of art' with mosaics and painted panels depicting the 'Tree of Life' (see fold-out). By the time he started working on this commission, Klimt had advanced to become one of the leading exponents of Art Nouveau and, today, is considered one of the greatest decorative painters of the twentieth century.

In 1905 Klimt resigned from the Secession. He became increasingly isolated from the development of the Austrian avant-garde and

devoted himself more to landscape painting and portraiture.

The majority of the artist's sitters belonged to the upper-middle classes and included the wives and relatives of wealthy Viennesse bankers and influential industrialists. The first portrait of Adele Bloch-Bauer (see p. 21) marks the height of Klimt's 'golden style' which emerged after his having seen a number of early Christian mosaics in Italy in 1902. His paintings began to display a growing preoccupation with ornamentation and contour, lending subjects an exaggerated, iconic appearance, detached from reality, as in *The Kiss*. The backgrounds consist of gold swirls, discs and shapes, while coloured, geometric patterns lend contour to the figures. In later portraits, Klimt incorporated motifs derived from Japanese screens and Oriental ceramics (see p. 28).

The portraitist once remarked that one of his main interests in life was "other people, above all females." Despite a string of ill-concealed

relationships with prominent patrons and impoverished models alike, there was, however, one women, the fashion designer Emilie Flöge (see p. 30), who remained a lifelong companion and with whom, paradoxically, he seems to have maintained a platonic relationship right up until his death.

All the portraits are painted in oil and were carefully prepared in numerous sketches. He worked slowly and conscientiously, completing on average just one portrait a year even though he could have taken on many more commissions than he did. They are almost invariably flattering, surrounded by gentle, swirling background decoration which perfectly captures the *fin-de-siècle* atmosphere, the fashionable accessories and decorative elements all being executed with precision. These portraits contrast with the women in his symbolic works in which the figures' sensuality and eroticism are exaggerated.

Of the more than 220 known works by Klimt, over sixty are landscapes, almost all of which were created during the summer months spent

in the country. Lake Atter, near Salzburg, and its vicinity provided the most frequently depicted subjects, which vary from ponds, studies of trees, flowers, farmhouse gardens and orchards, to views of villages and buildings painted across the water. He rarely painted landscapes outside Austria, with the exception of his views of Lake Garda in Italy. These undramatic, balanced compositions of stunning, atmospheric beauty, capture the peace of nature and lure the observer into a state of meditation, intensified by high horizons and the square format of his paintings – a format he used exclusively for his landscapes after 1899.

The style of Klimt's early landscapes with areas of filmy colour (see pp. 44/45) is also reflected in the *Portrait of Sonja Knips*, a work that shows a number of other similarities with landscape painting, both in the garden setting and in its format.

The landscapes all have a strong two-dimensionality without, however, forsaking the feeling

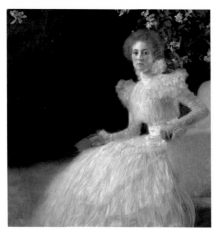

Portrait of Sonja Knips, 1898

of perspective. There is also a general absence of
light and shade and nowhere does Klimt attempt
to capture the moods of the weather.

Subjects along the shores of the lakes were
selected through a viewfinder, a square cut-out
in a piece of cardboard which enabled the artist

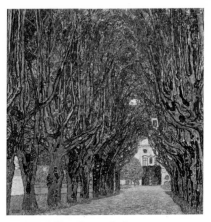

Avenue in Schloss Kammer Park, 1912

to choose the precise area he wanted to paint.
To reduce the horizon and intensify the detailing,
Klimt frequently used a telescope to focus on the
opposite shore and to zoom in on his subject. He
would always start his landscapes in front of his
motif, making brush sketches directly on the
canvas, before working on the colouring of the

main areas. Only when he felt confident that he would be able to complete the picture later in his studio in Vienna, did he stop painting.

Despite the fact that his output was small, producing on average between four and six canvases a year, and bearing in mind that many of his most important paintings were destroyed during World War II, Klimt's work has nonetheless attained universal popularity and acclaim. He had no pupils, founded no school, nor did he produce any manifestos, autobiographical statements or pronouncements on art. Nevertheless, the acknowledged leader of the Secession movement that redefined Austrian art had a strong influence on his contemporaries – especially on the artists Oskar Kokoschka and Egon Schiele. Gustav Klimt lived for his art and never put himself in the foreground, stating in all modesty: "If anyone wants to find out about me … they should look carefully at my paintings." In this respect, his portraits, friezes and landscapes speak volumes.

Portraits

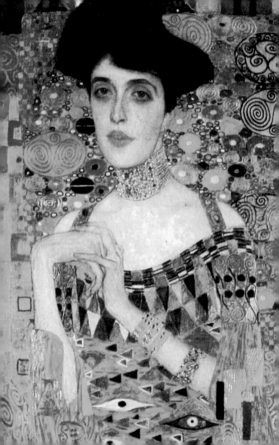

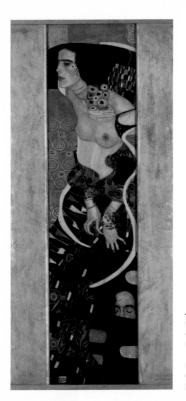

Judith II, 1909
Galleria Internazionale
d'Arte Moderna
(Cà Pesaro), Venice

(right) *Judith I,* 1901
Österreichische Galerie
Belvedere, Vienna

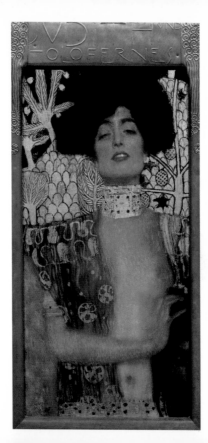

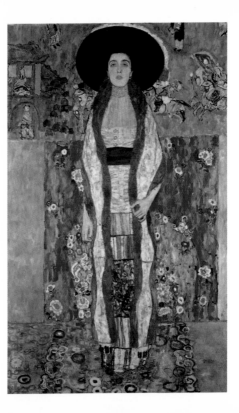

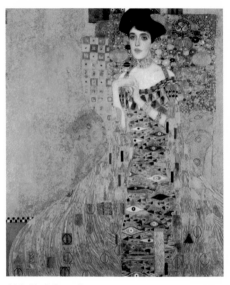

Adele Bloch-Bauer I, 1907
Österreichische Galerie Belvedere, Vienna

Adele Bloch-Bauer II, 1912
Österreichische Galerie Belvedere, Vienna

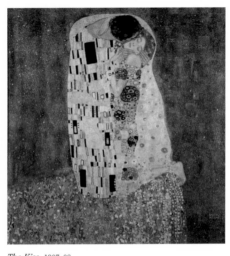

The Kiss, 1907–08
Österreichische Galerie Belvedere, Vienna

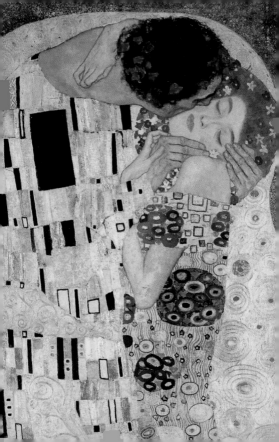

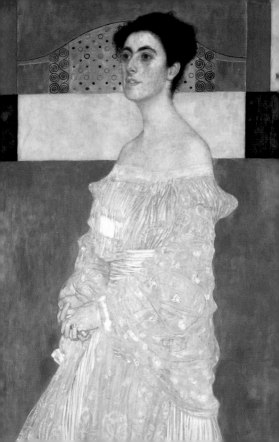

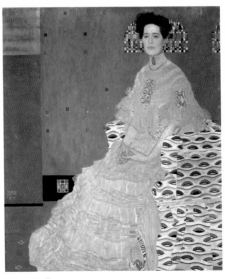

Fritza Riedler, 1906
Österreichische Galerie Belvedere, Vienna

Portrait of Margarethe Stonborough-Wittgenstein
(detail), 1905
Neue Pinakothek, Munich

25

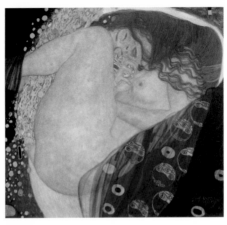

Danae, c. 1907/08
Private collection

(page 28) *Portrait of Friederike Maria Beer,* 1916
The Metropolitan Museum of Art, New York

(page 29) *Eugenia (Mäda) Primavesi,* c. 1913–14
Municipal Museum of Art, Toyota

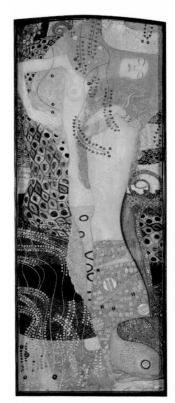

Water Serpents I,
1904 – 07
Österreichische
Galerie Belvedere,
Vienna

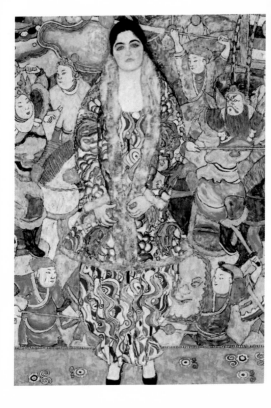

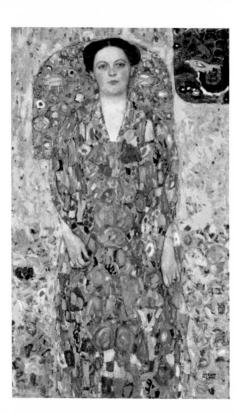

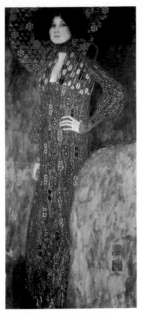

Emilie Flöge, 1907
Bequest of Emilie Flöge, Wolfgang Georg Fischer, Vienna

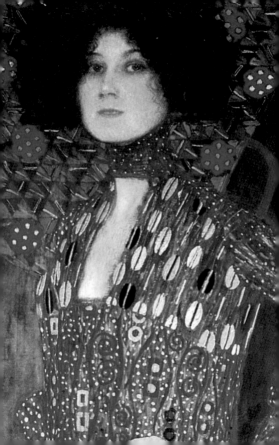

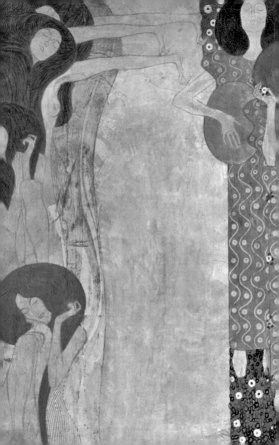

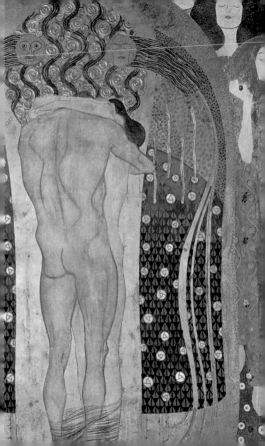

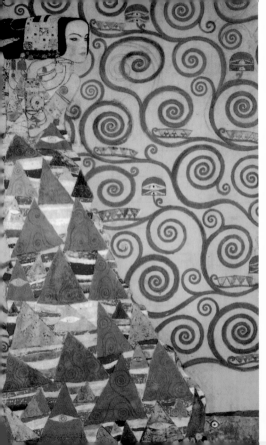

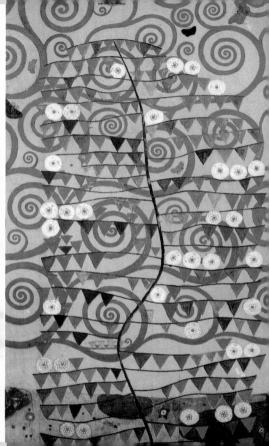

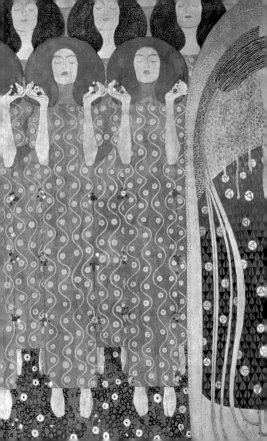

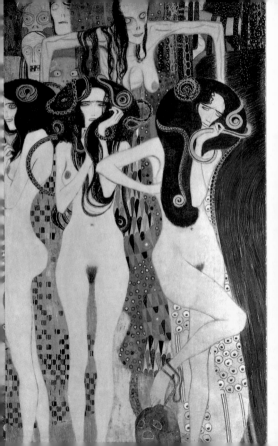

Landscapes

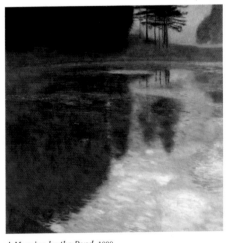

A Morning by the Pond, 1899
Leopold Museum – Privatstiftung, Vienna

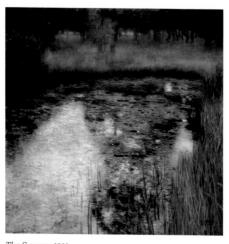

The Swamp, 1900
Private collection

Garden Path with Chickens, 1916
Lost in a fire at Schloss
Immendorf, Lower Austria,
in 1945

46

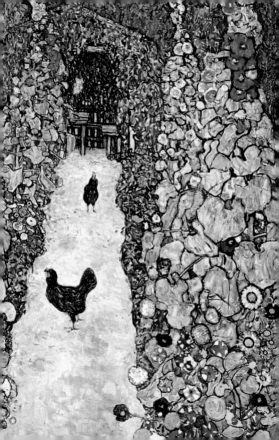

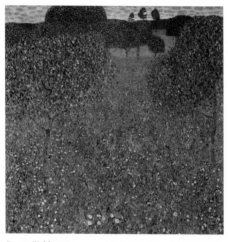

Poppy Field, 1907
Österreichische Galerie Belvedere, Vienna

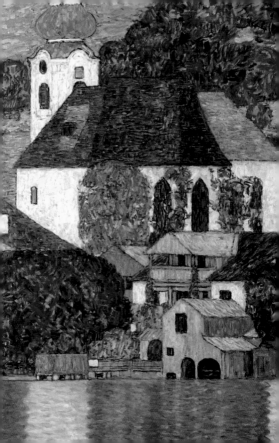

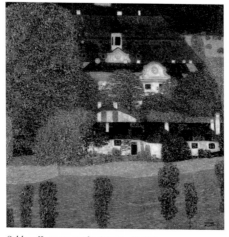

Schloss Kammer on the Attersee II, 1909
Private collection

Church at Unterach on the Attersee (detail), 1916
Private collection

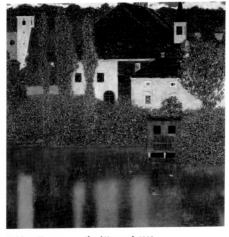

Schloss Kammer on the Attersee I, 1908
Národní Galerie v Praze, Prague

(pages 54 / 55)
Garden Landscape (Blooming Meadow), c. 1905/06
Private collection

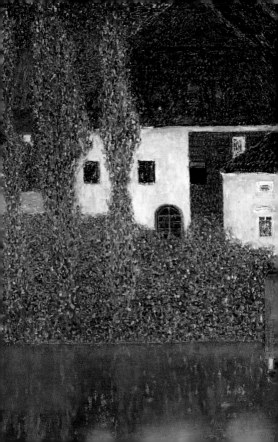

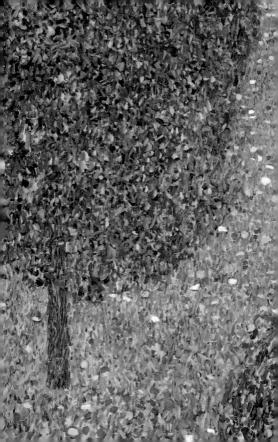

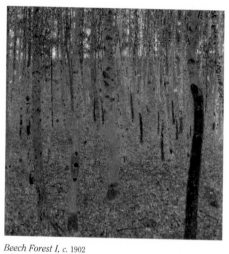

Beech Forest I, c. 1902
Gemäldegalerie Neue Meister
Staatliche Kunstsammlungen Dresden

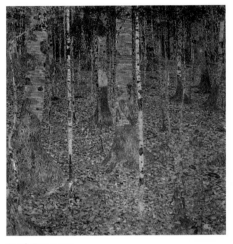

Beech Forest, 1903
Österreichische Galerie Belvedere, Vienna

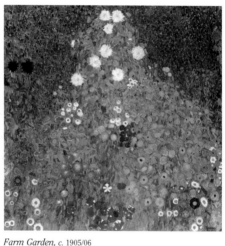

Farm Garden, c. 1905/06
Private collection

Farm Garden with Sunflowers (detail), *c.* 1907
Österreichische Galerie Belvedere, Vienna

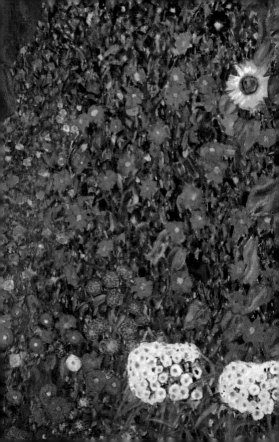

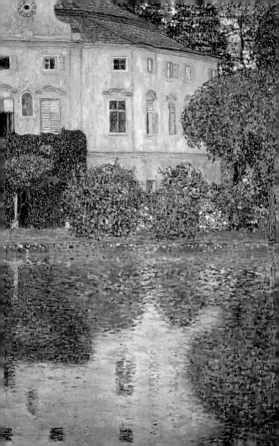

Pond at Schloss Kammer on the Attersee, 1909
Private collection

Schloss Kammer on the Attersee IV, 1910
Private collection

Cover: *The Kiss* (detail), see page 22; inside front cover and title page: *Attersee I* (detail), 1900, Leopold Musuem – Privatstiftung, Vienna; frontispiece: Gustav Klimt, *c.* 1909, photo: P. Hamilton; p. 7: *The Sunflower*, 1907, private collection; p. 13: *Portrait of Sonja Knips*, 1898, Österreichische Galerie Belvedere, Vienna; p. 14: *Avenue in Schloss Kammer Park*, 1912, Österreichische Galerie Belvedere, Vienna; pp. 16/17: *Adele Bloch-Bauer I* (detail), see page 21; pp. 42/43: *Island on the Attersee* (detail), 1902, private collection

The Library of Congress Cataloguing-in-Publication data is available; British Library Cataloguing-in-Publication Data: a catalogue record for this book is available from the British Library; Deutsche Bibliothek holds a record of this publication in the Deutsche Nationalbibliografie

© Prestel Verlag, Munich · Berlin · London · New York, 2004

Prestel Verlag, Königinstrasse 9, 80539 Munich
Tel. +49 (89) 38 17 09-0; Fax +49 (89) 38 17 09-35

Prestel Publishing Ltd., 4 Bloomsbury Place, London WC1A 2QA
Tel. +44 (020) 7323-5004; Fax +44 (020) 7636-8004

Prestel Publishing, 900 Broadway, Suite 603, New York, NY 10003
Tel. +1 (212) 995-2720; Fax +1 (212) 995-2733
www.prestel.com

Design and layout: Meike Sellier, Matthias Klesatschek
Origination: ReproLine Genceller, Munich
Printing: Jütte-Messedruck, Leipzig
Binding: Kunst- und Verlagsbinderei, Leipzig

Printed in Germany on acid-free paper

ISBN 3-7913-3084-5